JACOB LAWRENCE
Aesop's Fables

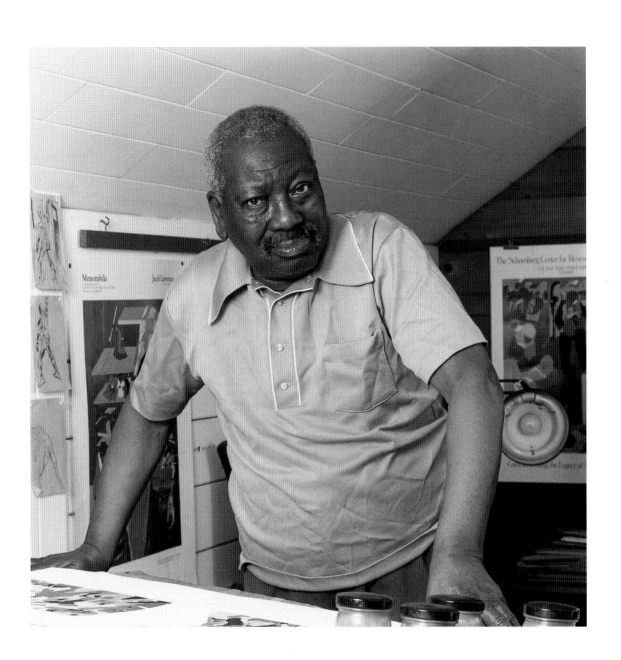

JACOB LAWRENCE

Aesop's Fables

UNIVERSITY OF WASHINGTON PRESS
SEATTLE AND LONDON

Copyright © 1997 by the University of Washington Press

Frontispiece: *Jacob Lawrence in His Studio*, 1994. Photo by
Spike Mafford.

All illustrations are by Jacob Lawrence, 1969, ink on paper. Sizes vary
in height from 12¾ in. to 19¾ in. and in width from 9¾ in. to 30 in.

The stories "The Birds, the Beasts, and the Bat," "The Lion and the
Three Bulls," "The Porcupine and the Snakes," "The Raven and the
Swan," and "The Two Frogs" retold by Laura Iwasaki, 1997.

Designed by Susan E. Kelly
Produced by Marquand Books, Inc., Seattle
Text set in Bell, with display type set in Penumbra

Library of Congress Cataloging-in-Publication Data
Aesop's fables. English. Selections.
 Aesop's fables / [illustrated by] Jacob Lawrence.
 p. cm.
 Contains 23 fables, the full complement of Lawrence's illustra-
tions, 18 of which were originally published by Windmill Books
in 1970.
 ISBN 0-295-97641-1 (alk. paper)
 1. Fables, Greek—Translations into English. I. Aesop.
II. Lawrence, Jacob, 1917– . III. Title.
PA3855.E5L36 1997
398.24'52—dc21 97-8783

The paper used in this publication meets the minimum requirements of
American National Standard for Information Sciences—Permanence of
Paper for Printed Library Materials, ANSI Z39.48-1984.

Printed by C & C Offset Printing Co., Ltd., Hong Kong

Contents

Note from the Publisher

Jacob Lawrence feels that Aesop's fables have always been part of his life. Thus, when given the opportunity to illustrate two literary subjects, he chose the fables (*Aesop's Fables*, Windmill Books/Simon and Schuster, 1970), because of his longtime fascination with them, and the story of Harriet Tubman (*Harriet and the Promised Land*, Windmill Books/Simon and Schuster, 1968), because of its drama.

Lawrence was intrigued by the opportunity to cast animals and insects as main characters. He first sketched out the scenarios using humans and as the sketches evolved into their final form, replaced the human characters with their anthropomorphized counterparts. Although Lawrence illustrated twenty-three fables, only eighteen were included in the original edition. We are pleased to present here, in a newly designed edition, the full complement of Jacob Lawrence's *Aesop's Fables*.

JACOB LAWRENCE
Aesop's Fables

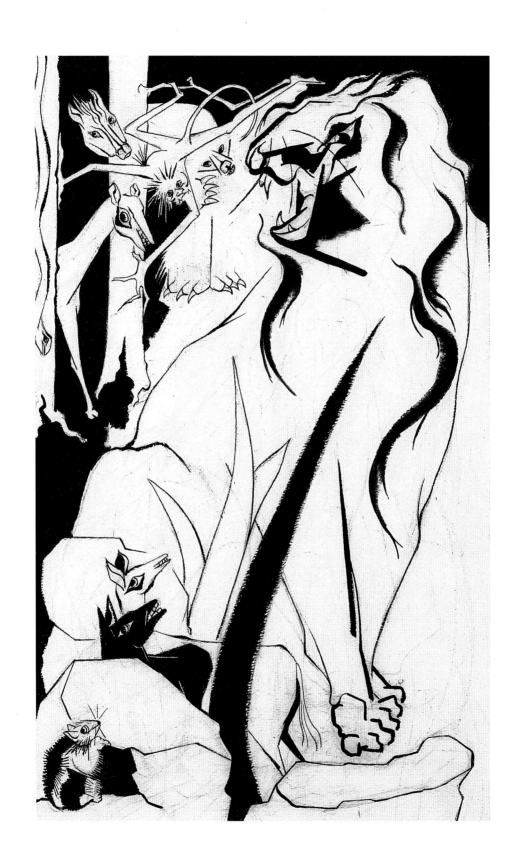

THE LION AND OTHER BEASTS GO HUNTING

One day, tired of hunting by himself, the lion gathered some other beasts together and suggested they go on a hunt. Proud to be at the side of such a great hunter, the other beasts were happy to join him. The hunters cornered and killed a fat juicy stag. The lion stood over the fallen prey.

"Beasts," he roared, "we shall now divide the spoils fairly. First, the stag shall be quartered. The first quarter shall be mine, as I am the king of beasts.

"The second is mine, as this hunt was my idea.

"The third quarter is mine, for I led the chase."

"And the fourth quarter, sire?" asked the monkey.

The lion drew himself up and gave an ominous growl. "As for the fourth quarter—let him take it who dares."

Moral: Many may share in the labor but not in the spoils.

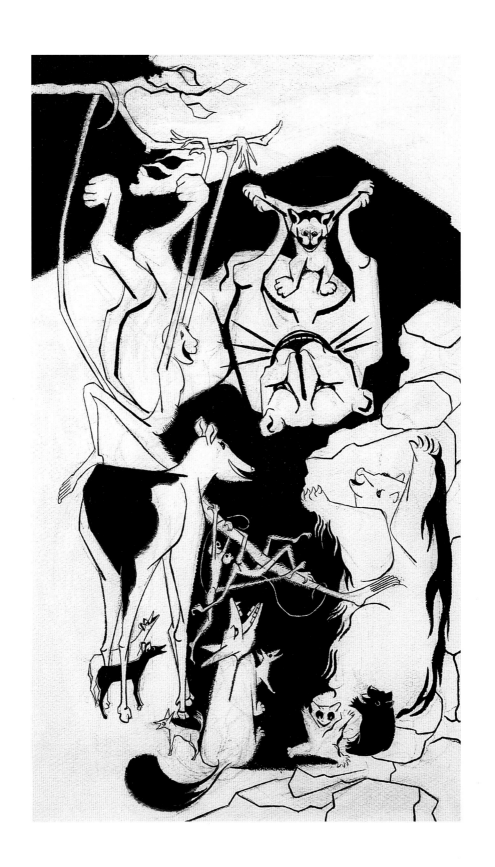

THE LIONESS

All the beasts of the forest were boasting of who among them could produce the largest litter.

Some admitted to having only two, while others boasted proudly of having a dozen.

"And to how many cubs do you give birth?" a monkey asked the lioness.

"To one," she replied, "but *that* one is a lion."

Moral: It is quality, not quantity, that counts.

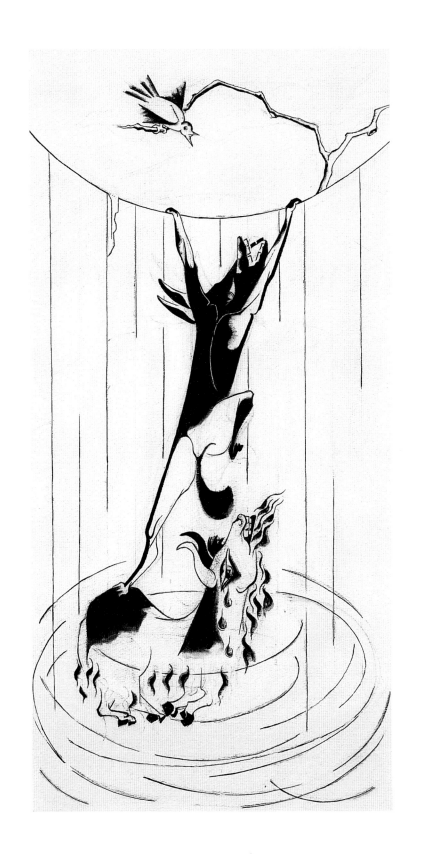

THE FOX AND THE GOAT

One day a fox fell into a deep well from which he could not escape. Just as he was about to give up hope, a goat came by to quench his thirst.

Seeing the fox in the well, the goat exclaimed, "What in the world are you doing in that well, old fox?"

"Haven't you heard news of the great drought? As soon as I heard, I jumped down here where the water is cool and plentiful. It is delicious too, and I have drunk so much I can hardly move."

When the goat heard this, he jumped into the well, and the fox immediately jumped onto the goat's back and up his horns, scrambling to safety.

Moral: It is not safe to trust the advice of a man in difficulties.

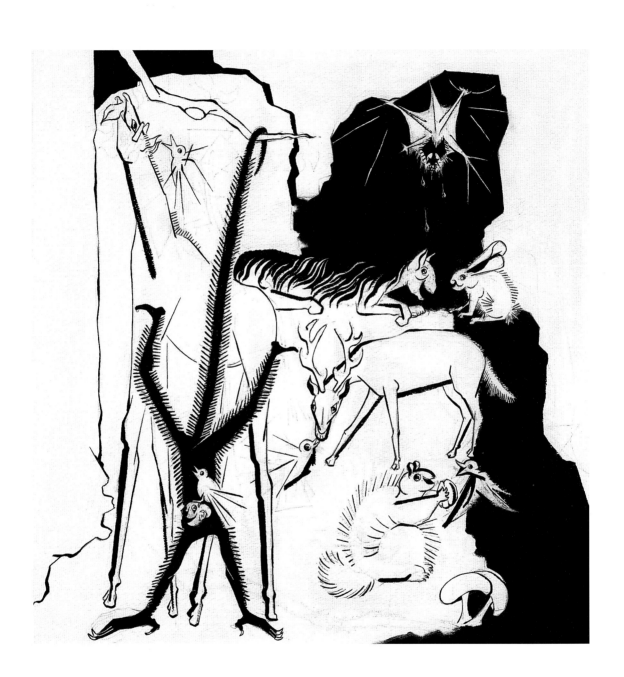

THE BIRDS, THE BEASTS, AND THE BAT

In a war between the birds and the beasts, the bat swore allegiance first to one side, then to the other. Having wings, he could easily claim kinship with the birds, but whenever his feathered comrades seemed on the verge of defeat, he pointed to his fur and joined the beasts instead.

Eventually, peace was declared, but both birds and beasts remembered the bat's disloyalty and refused to include him in their celebrations.

"Go away; you're not one of us," each side told him in turn.

And they drove him out into the night, which he inhabits to this day, sleeping and traveling in darkness when none can see him.

Moral: Serving two sides pleases neither.

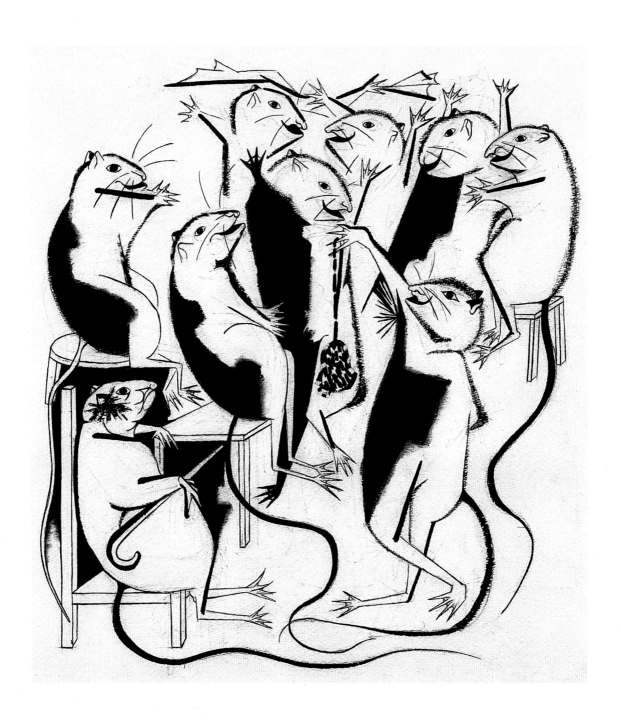

THE COUNCIL OF MICE

The mice lived in constant terror of the cat, whose greatest pleasure was toying with them and eating them up. The mice called a meeting to try to solve their problems. Many plans were discussed but none seemed right. What to do about the great cat?

At last a small mouse leaped up. He drew himself up to his full height. "I propose," he said, "that a bell be hung around the cat's neck so that whenever he approaches we will hear the bell tinkle and we shall be able to escape." All the mice applauded, and the young mouse took a few bows and then sat down.

After the motion was seconded and passed, a wise old mouse slowly rose to his feet. "My friends, fellow mice, our young friend has proposed a brilliant solution to end our constant fear and jeopardy from the cat. Only a mouse of great genius could have conceived such a simple solution, for indeed with the bell around his neck, we shall all most certainly hear Mr. Cat's no longer stealthy approach. But one question occurs to this old head. Who, may I ask, shall bell the cat?"

Moral: Easier said than done.

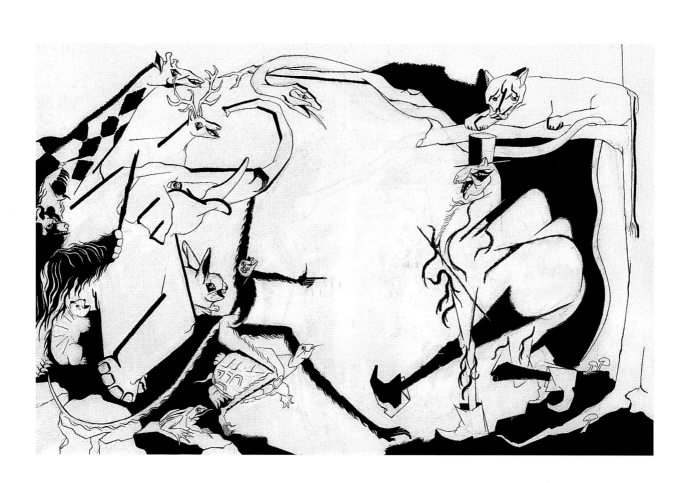

THE MONKEY AND THE CAMEL

The monkey was a great and nimble entertainer. At a grand gathering of all the beasts, the monkey danced and sang and told stories that made all the animals roar with laughter.

Only the camel seemed bored by the monkey's performances. "What a dull show you put on, little monkey," sniffed the camel. "It has almost put me to sleep."

"Can you do better?" asked the monkey.

"Of course I can," said the camel, shuffling onto the stage and doing a clumsy dance and singing an off-key song of the desert.

All the beasts booed her and set upon her with clubs and stones and drove the foolish camel out into the vast desert.

Moral: Stretch your arm no longer than your sleeve.

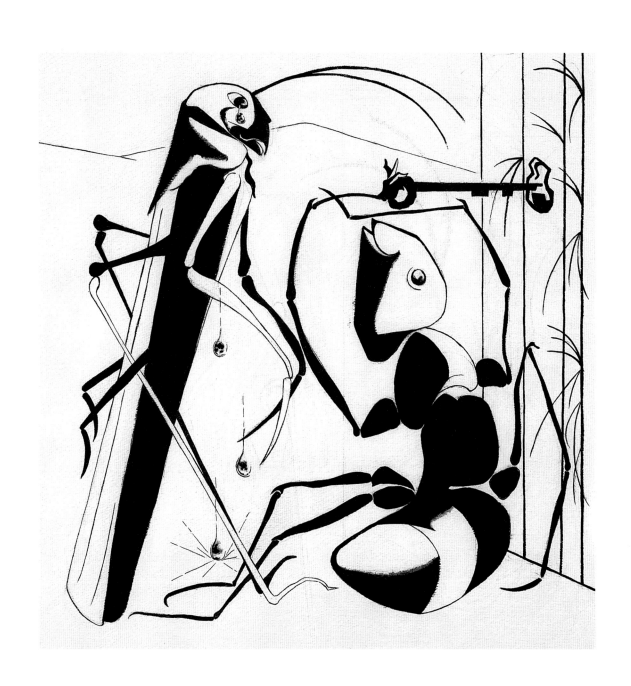

THE ANT AND THE GRASS-HOPPER

The grasshopper took his ease in the fields all summer long, chirping and singing, while his neighbor the ant plodded the dusty road carrying kernels of wheat to his nest. "What a stupid oaf to work in this heat," thought the grasshopper. "Summer is the time for fun."

But when winter came with its icy blasts, the grasshopper was cold and hungry, and he came shivering to the ant's nest begging for food. "Help me, I am starving," cried the grasshopper.

"Are you not the same grasshopper who was lazy and played in the fields all summer?" asked the ant.

"Yes, I am," said the grasshopper.

"Since you sang all summer," replied the ant, "you can dance all winter."

Moral: Prepare for the days of necessity.

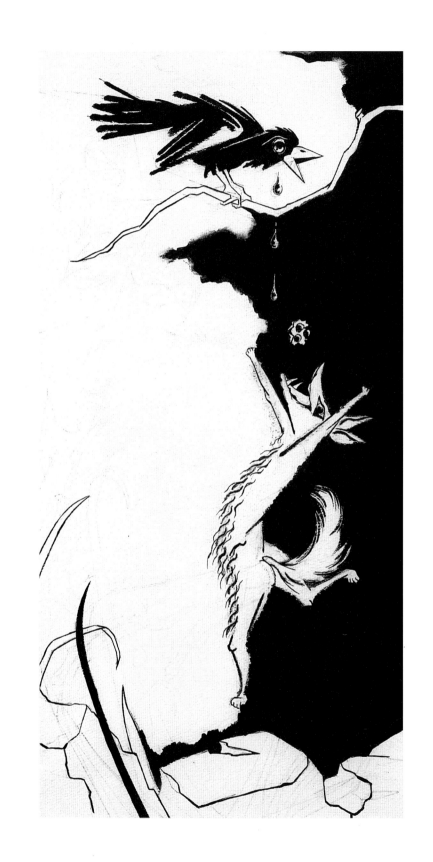

THE FOX AND THE CROW

The crow flew to the top of a tree to enjoy a piece of cheese she had stolen.

A wily fox spied the cheese in the crow's beak, and his mouth watered for it as he spoke these words: "O beautiful crow, charming crow, delightful crow, how wonderful to see you in all your glory!"

The crow smiled, holding the cheese firmly in her beak.

"You are the most exquisite of birds—and though I have not heard your voice, I am quite sure it must surpass that of any other bird."

The vain crow was pleased by all this flattery, especially the part about her voice, for she had sometimes been told that her caw was unpleasant. She opened her beak to sing for the fox, and out fell the cheese into the fox's watering jaws.

Moral: Beware of flattery.

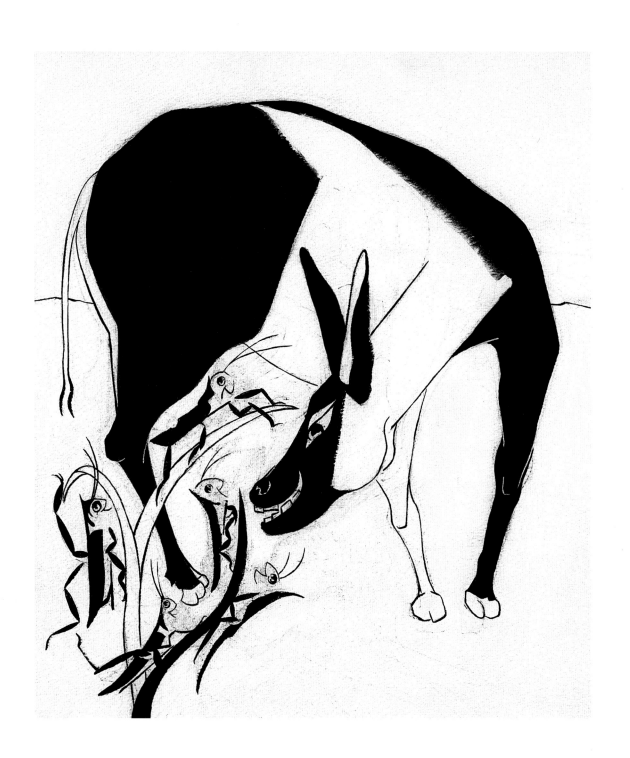

THE ASS AND THE GRASS- HOPPERS

One balmy summer day, an ass, who was also a music lover, heard some grasshoppers singing in perfect harmony. Hoping to learn to sing as sweetly as they, the ass questioned them.

"Musical grasshoppers," he brayed, "pray tell me what you eat that makes you sing so sweetly."

"We dine upon dew," replied the grasshoppers.

"Thank you so much," said the foolish ass, determined to live on the same diet.

Some time later he died of hunger.

Moral: It is impossible to become what one is not.

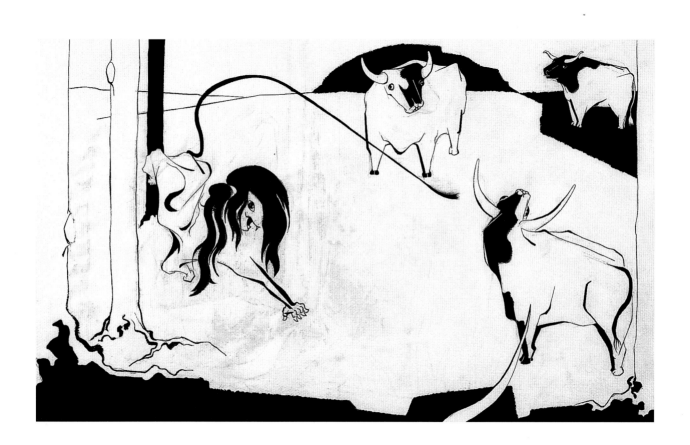

THE LION AND THE THREE BULLS

From afar, a hungry lion observed three bulls grazing beside one another in the same pasture. He imagined they would make a hearty meal, but he was afraid to attack all three at the same time.

Instead, he ambled closer and, displaying a friendly face, struck up a whispered conversation with the bulls, telling each one separately about a small spot where the grass was exceptionally sweet and tender. After advising them not to share this information, he watched as the bulls slipped away, to different sections of the field.

There, the lion ambushed them as they stood alone; then feasted on them one by one at his leisure.

Moral: There is strength in numbers.

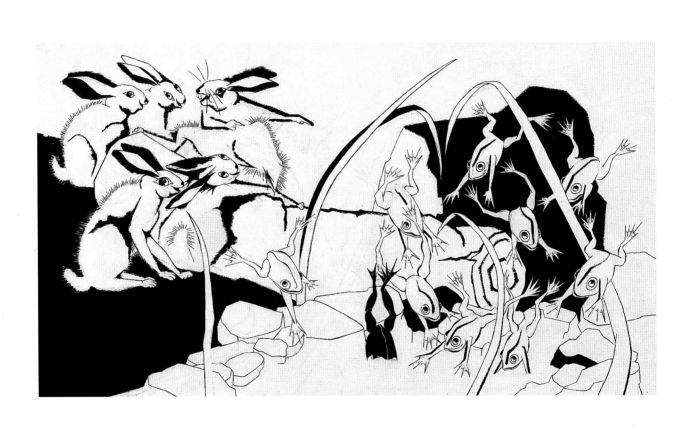

THE HARES AND THE FROGS

The hares lived in a constant state of fear, preyed upon by the large beasts of the forest. At last they held a meeting and decided to end it all, for living in such a state was not living at all. They followed their leader, who leaped into a pond, thereby frightening a troop of frogs, who leaped from the pond in terror.

"How wonderful," said the hares' leader. "There are others more frightened than ourselves. Life is worth living after all!"

Moral: There is always someone worse off than yourself.

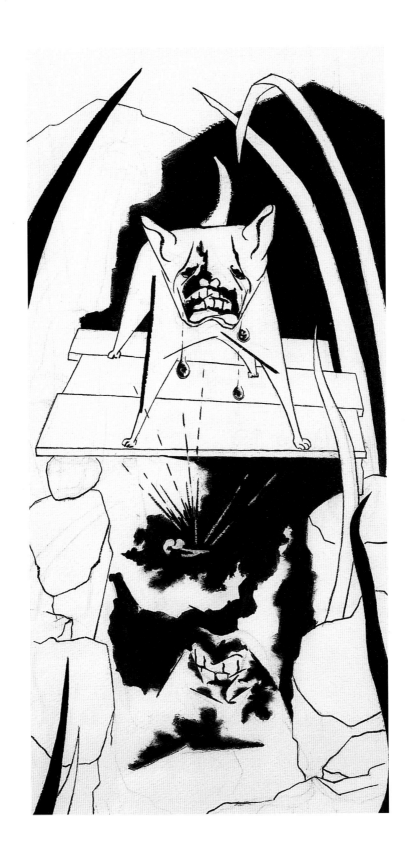

THE DOG AND THE BONE

One day a dog stole a bone from a butcher shop and was carrying it home in his mouth to eat in peace. On his way home he had to cross a plank over a river. Upon looking down, he saw his reflection in the water.

"What a delicious bone that strange dog is carrying!" he growled to himself. "I must have it."

So saying, the greedy dog snapped at his reflection in the water, losing the bone he had stolen, which fell into the water and sank.

Moral: Grasp at the shadow and lose the substance.

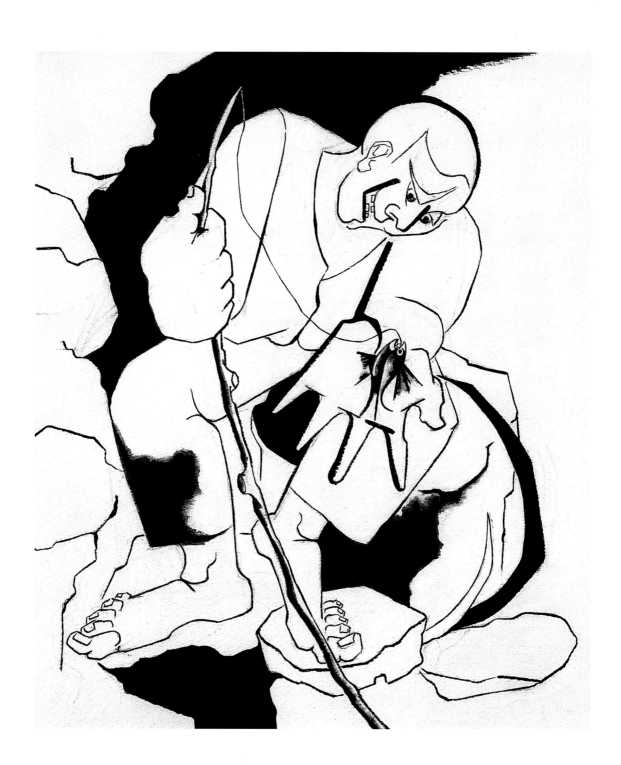

THE ANGLER AND THE LITTLE FISH

All day long the angler fished without a single bite. Just as he was about to call it a day, there was a small tug at his line and he pulled in a tiny perch.

"O please spare me, fisherman," cried the perch. "I am so small, I am hardly a mouthful. But I do have an idea. Throw me back into the river and let me grow big and plump enough to make you a tasty meal. Then come back and I'll let you catch me again, and we'll all be happy."

The fisherman thought a moment and then shook his head. "No, no," he said, "I have you in hand now, but once you get back into the water your tune will be, 'Catch me if you can!'"

Moral: Beware the promises of a desperate man.

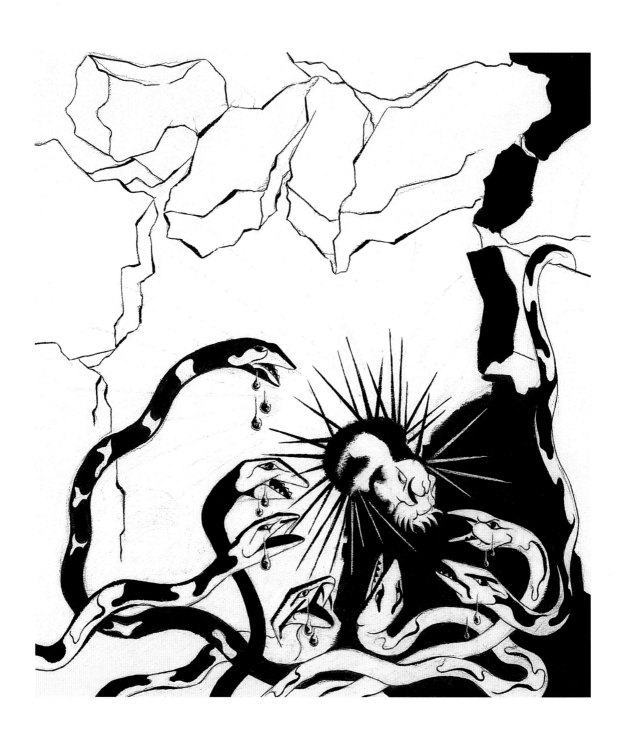

THE PORCUPINE AND THE SNAKES

One cold, wet day, a porcupine was searching for shelter from the pouring rain. Finally, she found a den of snakes, who invited her in.

"Snakes!" she shuddered. But she was desperate, and as the snakes seemed mild and amiable, she entered and began to feel quite at home.

The snakes, on the other hand, found that their guest's presence created remarkable discomfort. No matter how they twisted and coiled, there was another quill, waiting to poke them!

"We're sorry, but we must ask you to leave now," they said.

But the porcupine liked being warm and dry. "I, myself, intend to stay," she replied. "You may go, or stay if you choose. It's all the same to me."

Moral: Temper generosity with wisdom.

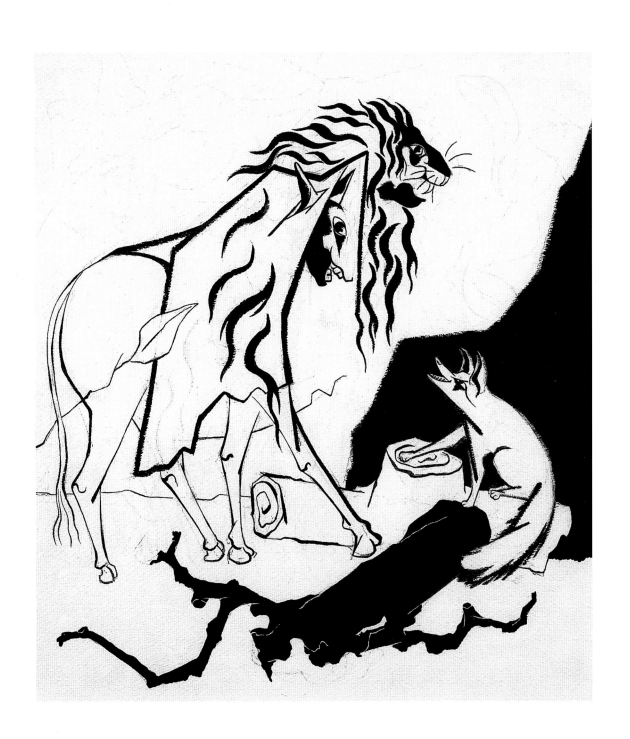

THE DONKEY IN LION'S SKIN

One day a silly donkey found a lion's skin and put it on. In this frightening disguise, he ran about the forest, scaring all the animals he met. He came upon a fox and tried to frighten him too. But the fox stood his ground and laughed in the donkey's face. "If you want to frighten me, Mr. Donkey," he said, "you must first disguise your bray."

Moral: A fool may wear a disguise, but his words will give him away.

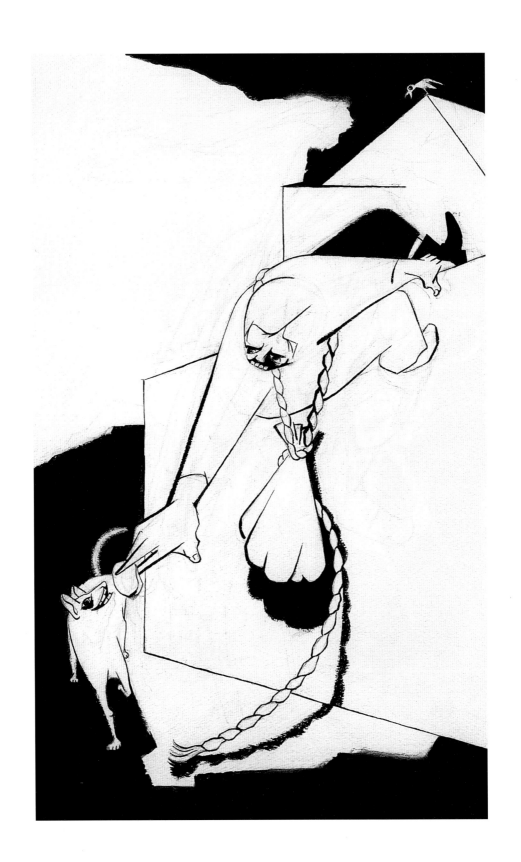

THE THIEF AND THE DOG

"Ruff, ruff," barked the watchdog as the thief clambered over the wall.

"Shhhh. Be still!" said the thief. "I am your master's friend."

"Ruff, ruff!" The watchdog barked more loudly. Hoping to quiet him, the thief reached into his bag and tossed the dog some scraps of food. "You are a thief, not my master's friend," snapped the dog, "else you would not have to be so free with your gifts."

And he continued barking until the whole house was awakened.

Moral: A bribe in the hand betrays mischief at heart.

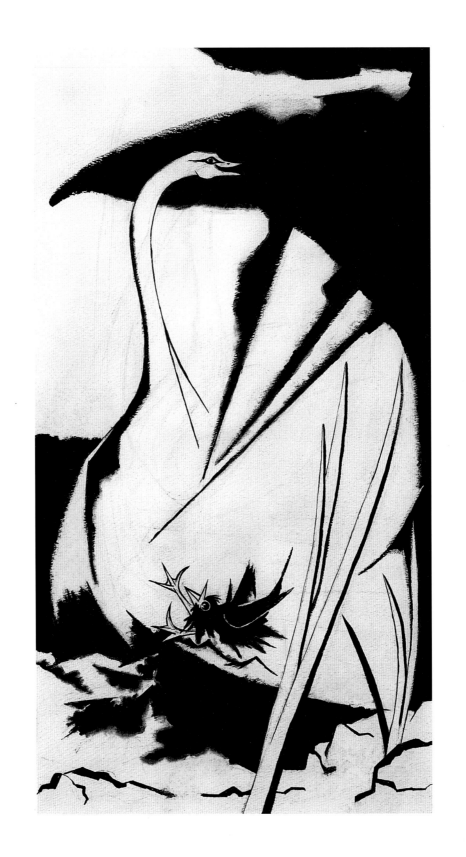

THE RAVEN AND THE SWAN

A raven saw a swan and envied the other bird's beautiful white plumage.

"Perhaps it's because he spends so much time in the water," mused the raven, supposing he might wash his own feathers clean and achieve the dazzling hue he admired.

With this aim in mind, he traded his customary haunts for the swan's lakes and streams. But his constant bathing failed to transform his feathers, and at last, grown thin and weak from lack of food, he died.

Moral: A change of habit won't alter Nature.

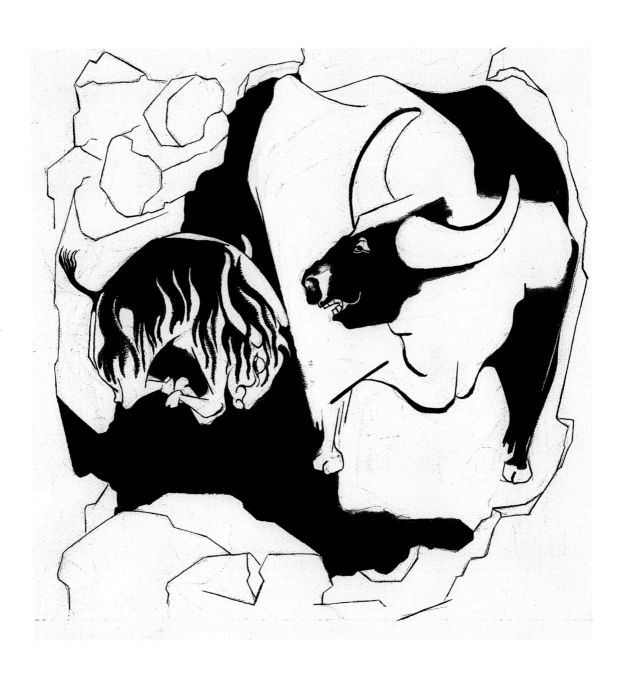

THE BULL AND THE GOAT

A bull was chased by a lion and took shelter in a cave wherein lived a wild goat. Annoyed at the intrusion, the goat began to butt the tired and bleeding bull. The bull did nothing, but said to the goat, "Because I allow you to butt me now does not mean that I am afraid of you. I have greater matters on my mind. But as soon as that lion is gone, and my present danger is past, I'll show you the difference between a lion and a goat."

Moral: Those who take advantage of their neighbor's temporary difficulties may live to regret it.

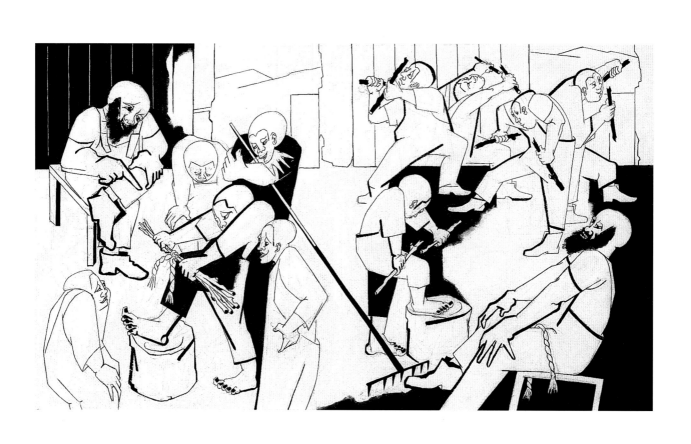

THE BUNDLE OF STICKS

Once there was a farmer with many sons, who were always fighting and quarreling among themselves. One day he called his sons together. Before him lay a bundle of sticks tied together.

He commanded each son to take up the bundle of sticks and break it in two. Each son tried and each one failed. Then the father untied the bundle and gave them the sticks to break one by one. They did this with ease.

"My sons," said the father, "by this example you can see that there is strength in being together. But once you quarrel and are separated, you are easily destroyed."

Moral: In unity there is strength.

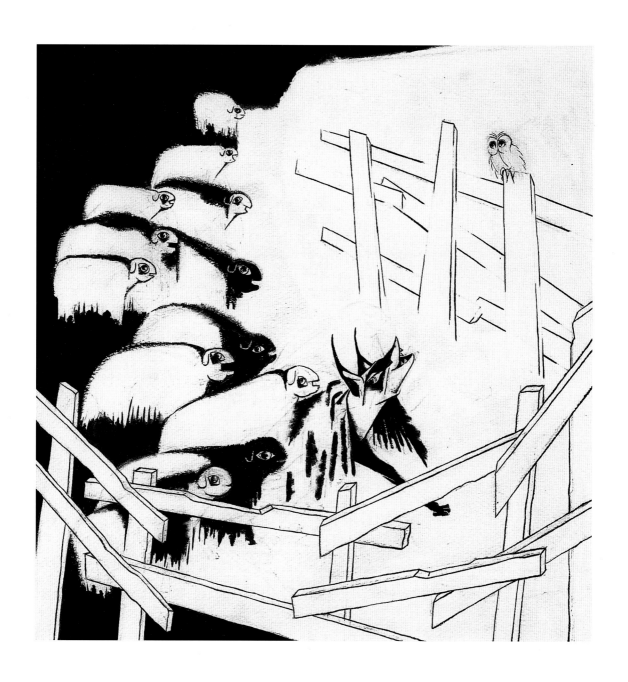

THE WOLF IN SHEEP'S CLOTHING

A fierce wolf had been stalking a flock of sheep for many days, but the shepherd had been so vigilant in guarding his animals that the wolf had been unable to catch one.

"I shall disguise myself," said the wolf. He wrapped himself in a sheepskin and made his way among the grazing sheep. "Baa, baa," said the wolf, deceiving both the shepherd and his sheep.

When night came, the shepherd led his flock of sheep, including one wolf in sheep's clothing, into the fold.

Later that evening the shepherd wanted something for his supper. He went down to the fold and seized the first animal he came upon. It was the wolf in sheep's clothing, and the shepherd feasted on wolf that night.

Moral: Every deceit has its dangers.

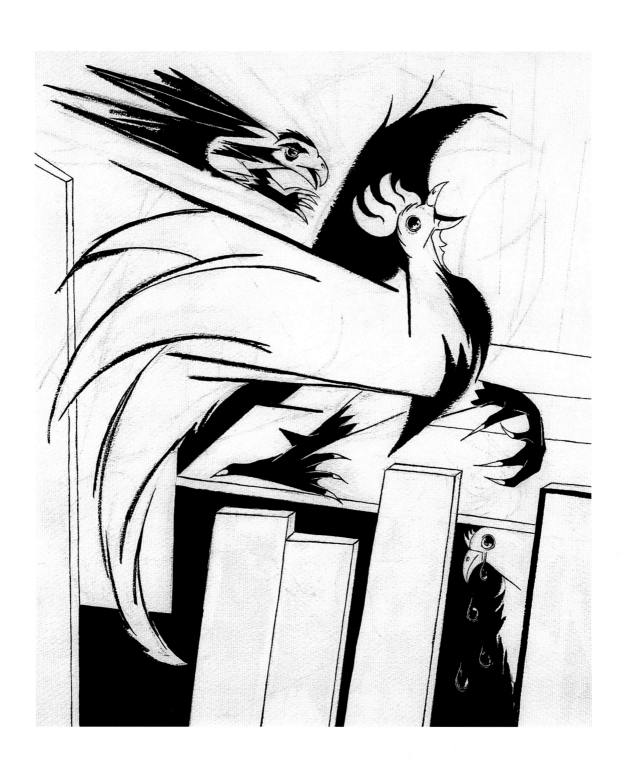

THE FIGHTING COCKS AND THE EAGLE

Two proud young fighting cocks were battling mightily to decide who would be king of the barnyard. After the battle, the victor flapped his wings and crowed heartily while the loser crept away to salve his wounds and his shame. His conqueror flew to the top of the barn, where he crowed his song of victory for all to hear.

A passing eagle heard the cock's crow and swooping down, seized him in his sharp talons and carried him home to dinner.

Seeing this sight, the beaten rooster raised himself up and took possession of the barnyard.

Moral: Pride goeth before a fall.

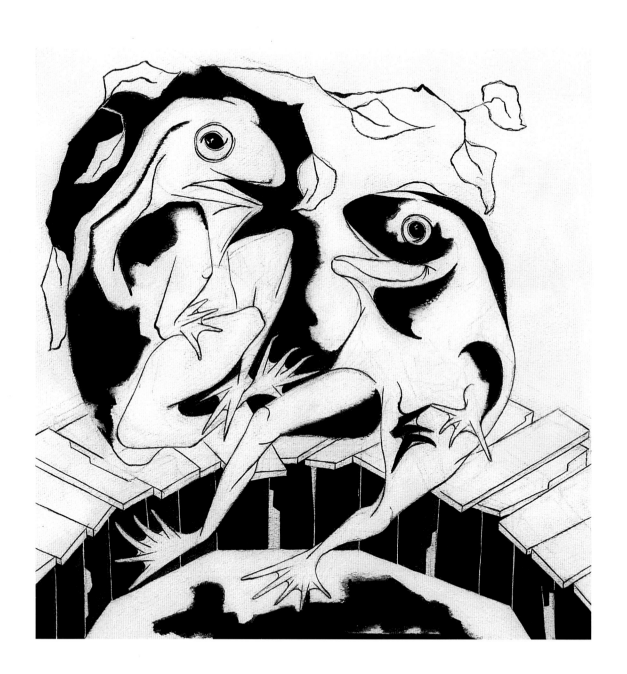

THE TWO FROGS

When their pond dried up in the fierce heat of the summer's sun, two frogs were forced to look for a new home. Soon enough, they came upon a deep well filled with water.

"Look," said the first frog, "let's jump in and make ourselves comfortable. It has everything we need."

But the other frog cautioned, "Not so fast. See how far down it goes? If the water dries up here, too, how will we ever get out again?"

Moral: Consider the consequences.

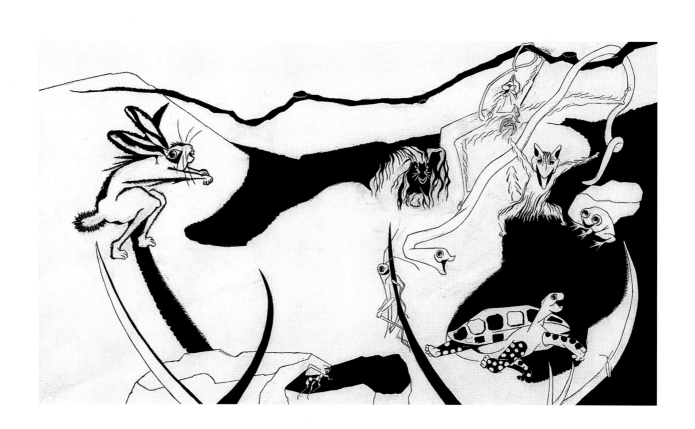

THE TORTOISE AND THE HARE

The hare was very proud of his fleetness of foot and enjoyed teasing the tortoise for being so slow and plodding. At last the tortoise could not abide the teasing any longer, and he challenged the hare to a foot race.

"You challenge me to a race?" said the hare. "That is ridiculous!"

"Enough talk," snapped the tortoise. "Let the race begin."

The course was set by the animals, and the fox was chosen as judge. He gave a sharp bark and the race was begun. In a flash the hare was out of sight, far ahead of the plodding tortoise.

"Ho hum," yawned the hare, "I have time to take a nap and still beat that slowpoke." So he stretched himself out on a grassy knoll and snoozed in the afternoon sun.

Onward plodded the tortoise. He plodded beyond the sleeping hare. He plodded over the finish line! The hare woke up with a start to realize the race was lost.

Moral: Slow and steady wins the race.

Jacob Lawrence (b. 1917) is one of America's most celebrated artists. His awards include his election in 1983 to the American Academy of Arts and Letters and in 1995 to the American Academy of Arts and Sciences, a National Arts Award in 1992, and his confirmation as Commissioner of the National Council of the Arts in 1978 by the U.S. Senate. He is professor emeritus of art at the University of Washington, and has also taught at the Pratt Institute, Brandeis University, and Black Mountain College. His paintings have been widely exhibited since his first major solo exhibition in 1944 at the Museum of Modern Art, New York, and his work graces museums and private collections throughout the world.